T. [handwritten inscription]

[handwritten signature]

Isaac Newton
Opticks or A Treatise of the Reflections,
Refractions, Inflections & Colours of Light,
Book III, Pt 1, Query 30
(London, 1706)

The changing of bodies into light, and light into bodies, is very comfortable to the course of Nature, which seems delighted with transmutations.

These exercises are intended to allow you to become invisible. This does not, however, mean that you will physically disappear or dematerialise. Instead you will be hidden from view, concealed within a cloud of your own creation. The cloud will be a gently glowing agglomeration of white light that surrounds you completely. Like the sun or a bare bulb it will be visible but unobservable, repelling the gaze of anyone who looks directly at it.

Once you have mastered these exercises you will be able to create the cloud at will, but this level of mastery requires practice. These exercises are not easy. If they were then everybody would be able to become invisible. It may take many attempts before you are able to produce even a single colour, and many more before you are able to manipulate the colours and create the white cloud. Perseverance is the key. The practice of these exercises should become a discipline that is followed regardless of the results. Then, perhaps unexpectedly, success will follow.

As with all such exercises it is better to do a little each day than to practice intensively only when the mood takes you. It is suggested that you begin with a few minutes in the morning, again after midday and finally in the evening. If the exercises can be done on an empty stomach then so much the better. Eventually they should be done for seven minutes each time, but it is wise to work up to this gradually.

The number seven has a special significance for the practice of these exercises. You will learn to perform seven prelude breaths, to breathe in for seven seconds, breathe out for seven seconds and to split and reconstitute the seven visible colours of the spectrum.

The exercises are best performed in a quiet, evenly lit room with white walls and a floor of bare boards or simple concrete. There is no need for special clothes or equipment. Stand away from the walls, in the centre of the space, and avoid looking directly at the light from any windows. Your gaze should be directed beyond the space. Imagine that the white of the wall is not a surface but a mist through which you are attempting to see for an infinite distance ahead.

Now begin by visualising the seven colours of the spectrum, or if it is easier, the rainbow. If you have difficulty visualising the spectrum then use this page as a reminder before you start the exercises.

Stand with your feet a little apart, spine straight and shoulders back. Your hands should hang loosely by your sides. Above all you should be comfortable and relaxed in your posture.

First take a series of seven quick prelude breaths, fully in and fully out, to empty the lungs of stale air.

Then start to breathe with the rhythm that is key to mastering these exercises. Breathe slowly in through your nose, allowing each breath in to take seven seconds.

Breathe slowly out through your nose, or through barely parted lips, again allowing each exhalation to take seven seconds.

Persist with this breathing pattern until it becomes natural and unforced.

Continue breathing in for seven seconds and out for seven seconds. Dismiss the spectrum from your mind and once more look into the white mist. Then begin to visualise a single colour.

First red. Breathe in white and breathe out red. Each time you breathe out the amount of red will increase. Continue breathing with the seven second rhythm. Each breath in should fill your body and anchor you to the floor, each breath out should empty your body and draw you upwards and outwards, filling the room with colour.

Continue to breathe in white and breathe out red. Allow the colour to softly fill the room in front of you. It will at first appear as though you are looking through a tinted glass, and then as you breathe ever more red into the space the coloured mist will slowly solidify until your gaze is filled by red.

Continue breathing in for seven seconds and out for seven seconds. Gradually allow the red to fade until the room is once more a white mist ahead of you.

Next orange. Breathe in white and breathe out orange. Each time you breathe out the amount of orange will increase. Continue breathing with the seven second rhythm. Each breath in should fill your body and anchor you to the floor, each breath out should empty the body and draw you upwards and outwards, filling the room with colour.

Continue to breathe in white and breathe out orange. Allow the colour to softly fill the room in front of you. The coloured mist will slowly solidify until your gaze is filled by orange.

Continue breathing in for seven seconds and out for seven seconds. Gradually allow the orange to fade until the room is once more a white mist ahead of you.

Next yellow. Breathe in white and breathe out yellow. Each time you breathe out the amount of yellow will increase. Continue breathing with the seven second rhythm. Each breath in should fill your body and anchor you to the floor, each breath out should empty the body and draw you upwards and outwards, filling the room with colour.

It is sometimes said that yellow is the easiest colour to produce. Do not let this make you complacent. Try to generate all of the colours with an equal attention and sincerity.

Continue to breathe in white and breathe out yellow. Allow the colour to softly fill the room in front of you. The coloured mist will slowly solidify until your gaze is filled by yellow.

Continue breathing in for seven seconds and out for seven seconds. Gradually allow the yellow to fade until the room is once more a white mist ahead of you.

Next green. Breathe in white and breathe out green. Each time you breathe out the amount of green will increase. Continue breathing with the seven second rhythm. Each breath in should fill your body and anchor you to the floor, each breath out should empty the body and draw you upwards and outwards, filling the room with colour.

Continue to breathe in white and breathe out green. Allow the colour to softly fill the room in front of you. The coloured mist will slowly solidify until your gaze is filled by green.

Continue breathing in for seven seconds and out for seven seconds. Gradually allow the green to fade until the room is once more a white mist ahead of you.

Next blue. Breathe in white and breathe out blue. Each time you breathe out the amount of blue will increase. Continue breathing with the seven second rhythm. Each breath in should fill your body and anchor you to the floor, each breath out should empty the body and draw you upwards and outwards, filling the room with colour.

Continue to breathe in white and breathe out blue. Allow the colour to softly fill the room in front of you. The coloured mist will slowly solidify until your gaze is filled by blue.

Continue breathing in for seven seconds and out for seven seconds. Gradually allow the blue to fade until the room is once more a white mist ahead of you.

Next indigo. Breathe in white and breathe out indigo. Each time you breathe out the amount of indigo will increase. Continue breathing with the seven second rhythm. Each breath in should fill your body and anchor you to the floor, each breath out should empty the body and draw you upwards and outwards, filling the room with colour.

Indigo is often described as the most difficult colour to generate. Yet if it is allowed to develop naturally and without undue haste then the correct colour will inevitably appear.

Continue to breathe in white and breathe out indigo. Allow the colour to softly fill the room in front of you. The coloured mist will slowly solidify until your gaze is filled by indigo.

Continue breathing in for seven seconds and out for seven seconds. Gradually allow the indigo to fade until the room is once more a white mist ahead of you.

Finally violet. Breathe in white and breathe out violet. Each time you breathe out the amount of violet will increase. Continue breathing with the seven second rhythm. Each breath in should fill your body and anchor you to the floor, each breath out should empty the body and draw you upwards and outwards, filling the room with colour.

Continue to breathe in white and breathe out violet. Allow the colour to softly fill the room in front of you. It will at first appear as though you are looking through a tinted glass, and then as you breathe ever more violet into the space the coloured mist will slowly solidify until your gaze is filled by violet.

When you are easily able to produce the colour fields then the next step is to manipulate these colours.

Once more stand in the centre of the space and assume the upright but relaxed posture. First take a series of seven quick prelude breaths, fully in and fully out, to empty the lungs of stale air.

Begin to breathe in for seven seconds and out for seven seconds. As before produce the red colour field. Then focus your gaze on a central point within the colour field. You will find that the colour is drawn inwards towards this central point.

As it is drawn inwards you should attempt to condense the red field until it forms a small cloud in the centre of the space. Initially the colour will tend to eddy and flow, refusing to agglomerate, but with practice you will find that it holds its circular form.

When you have produced the red cloud allow it to find its natural place – some colours will seek to rise, others to fall.

Do not dissolve the red cloud. Allow it to float in place and move on to producing the orange cloud. Continue to breathe in for seven seconds and out for seven seconds then once more fill the space with an orange field.

Focus your gaze on a central point within the colour and condense the orange field until it forms a small cloud in the centre of the space.

When you have produced the orange cloud allow it to find its natural place.

Do not dissolve the orange cloud. Allow it to float in place and move on to producing the yellow cloud. Continue to breathe in for seven seconds and out for seven seconds then once more fill the space with a yellow field.

Focus your gaze on a central point within the colour and condense the yellow field until it forms a small cloud in the centre of the space.

When you have produced the yellow cloud allow it to find its natural place.

Do not dissolve the yellow cloud. Allow it to float in place and move on to producing the green cloud. Continue to breathe in for seven seconds and out for seven seconds then once more fill the space with a green field.

Focus your gaze on a central point within the colour and condense the green field until it forms a small cloud in the centre of the space. The green cloud can be the most difficult to work with. It may drift and dissipate. Only practice will allow you to overcome this tendency.

When you have produced the green cloud allow it to find its natural place.

Do not dissolve the green cloud. Allow it to float in place and move on to producing the blue cloud. Continue to breathe in for seven seconds and out for seven seconds then once more fill the space with a blue field.

Focus your gaze on a central point within the colour and condense the blue field until it forms a small cloud in the centre of the space.

When you have produced the blue cloud allow it to find its natural place.

Do not dissolve the blue cloud. Allow it to float in place and move on to producing the indigo cloud. Continue to breathe in for seven seconds and out for seven seconds then once more fill the space with an indigo field.

Focus your gaze on a central point within the colour and condense the indigo field until it forms a small cloud in the centre of the space.

When you have produced the indigo cloud allow it to find its natural place.

Do not dissolve the indigo cloud. Allow it to float in place and move on to producing the violet cloud. Continue to breathe in for seven seconds and out for seven seconds then once more fill the space with a violet field.

Focus your gaze on a central point within the colour and condense the violet field until it forms a small cloud in the centre of the space.

When you have produced the violet cloud allow it to find its natural place.

The seven clouds of colour will tend to form a geometric shape, evenly spaced.

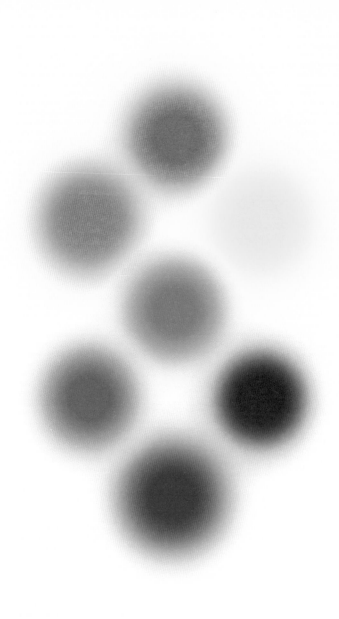

The next step is to begin to bring the clouds together.

Closer and closer.

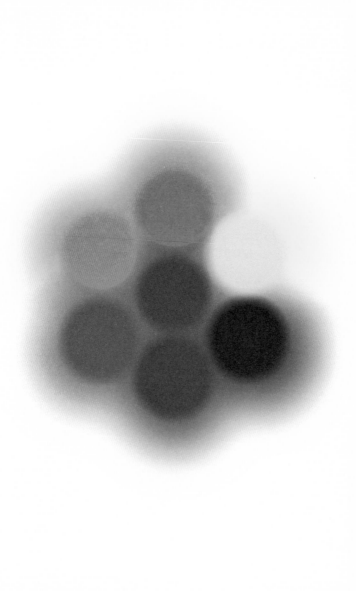

Finally they will merge, and as they do so will form the white cloud.

Step into the cloud and you will become invisible.